Clever dog!

First published in Great Britain in 2009 by

Quercus
21 Bloomsbury Square
London
WC1A 2NS

Copyright © Quercus Publishing Plc 2009

A CIP catalogue record for this book is available from the British Library

ISBN 978 1 84866 022 9

Printed and bound in China

10 9 8 7 6 5 4 3 2 1

Layout, picture research and authoring by Pikaia Imaging

Clever dog!

Quercus

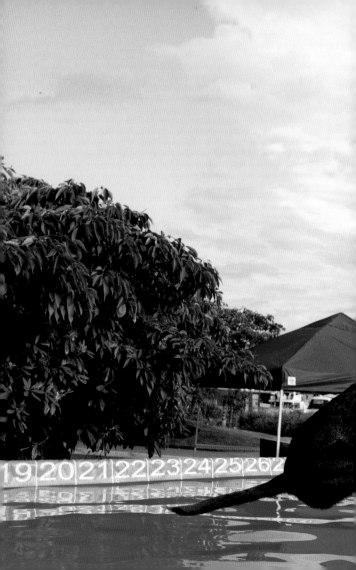

Look before you leap

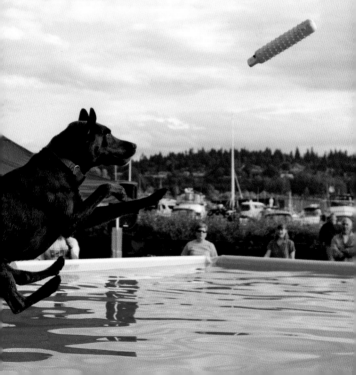

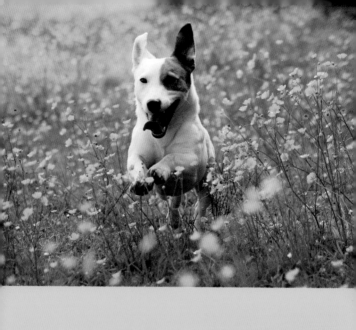

Time flies
when you're
having fun

They also serve who only stand and wait

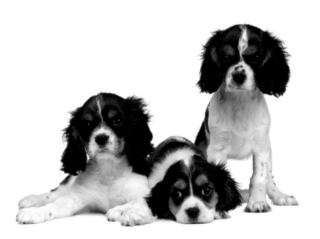

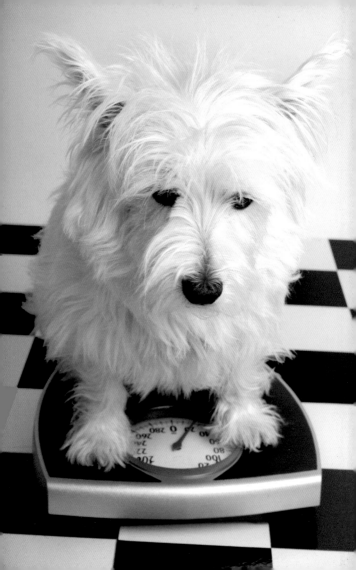

They
are also
weighed,
who only
stand and
serve

It's what is
inside that
counts

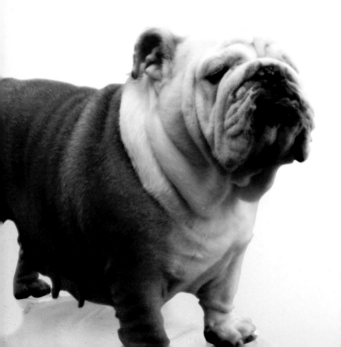

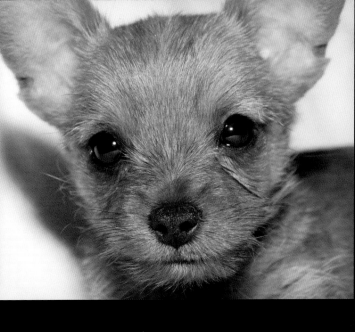

Size isn't everything

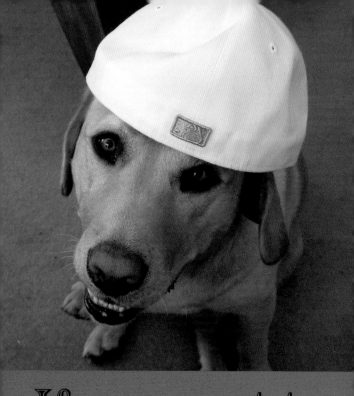

If you want to get ahead, get a hat

Travel broadens the mind

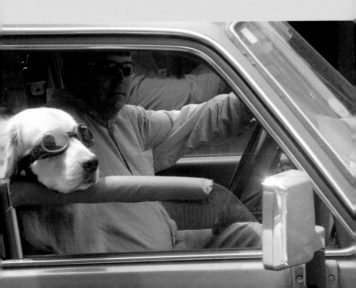

A journey of
a thousand
miles begins
with a single
step

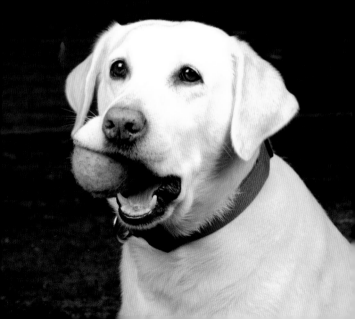

Don't bite off more than you can chew

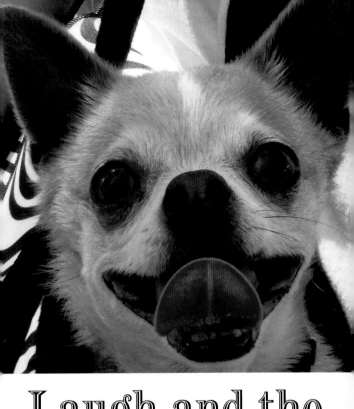

Laugh and the world laughs with you

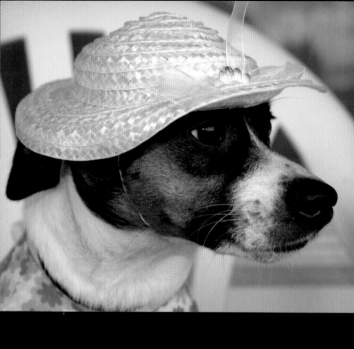

Clothes
maketh
the dog

Good fences make good neighbours

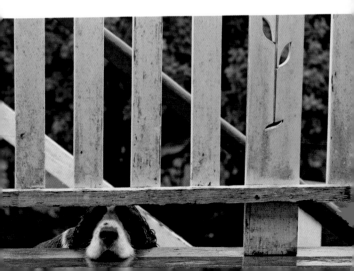

The bigger they are, the harder they fall

Youth is wasted on the young

Life is full
of ups and
downs

On a clear
day you can
see forever

What you
lose on the
swings you
gain on the
roundabouts

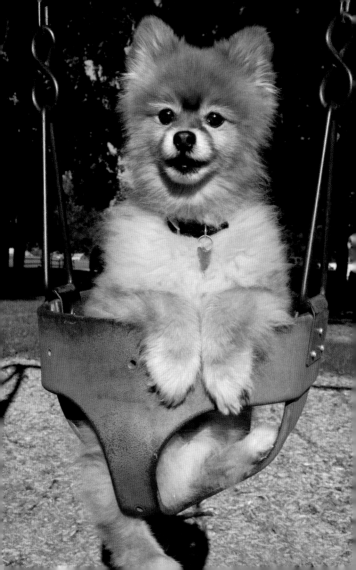

Put your best paw forward

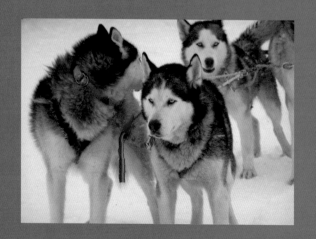

Many
hands
make light
work

Beauty is in the eye of the beholder

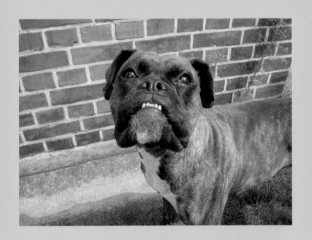

Two heads
are better

than one

Maybe
tomorrow
I'll wanna
settle down

Love me, love my human

You can't have too many dogs

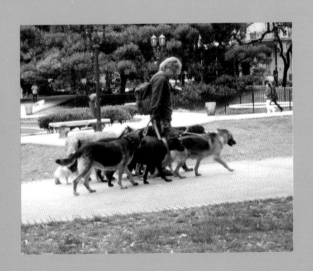

Home is where the heart is

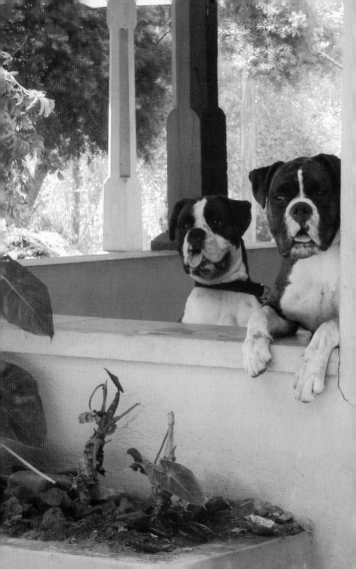

My home is

my castle

Birds of a feather stick together

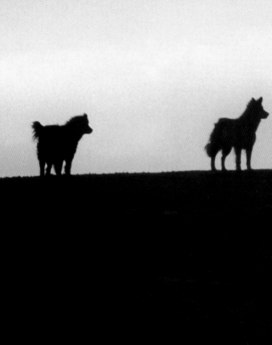

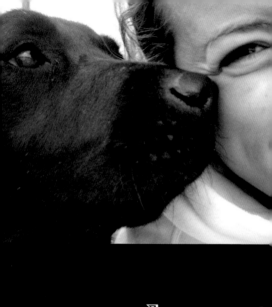

warm heart

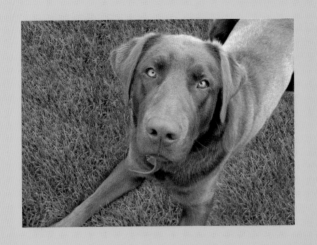

Things will
soon be
looking up

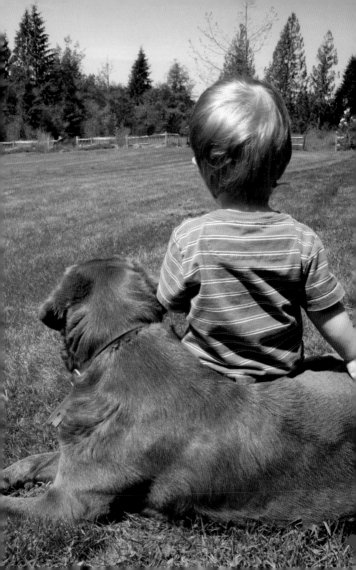

Sometimes we can't see the wood for the trees

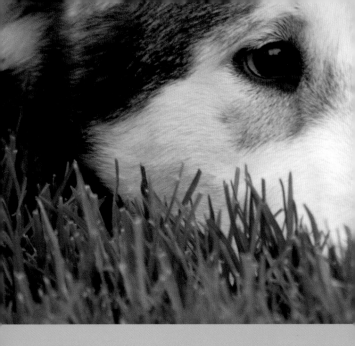

The grass
is always
greener

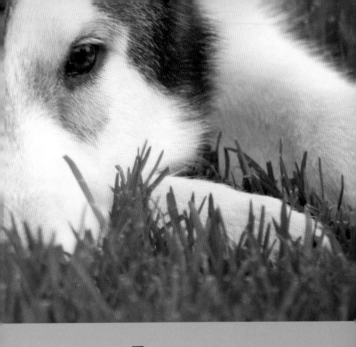

on the
other side
of the fence

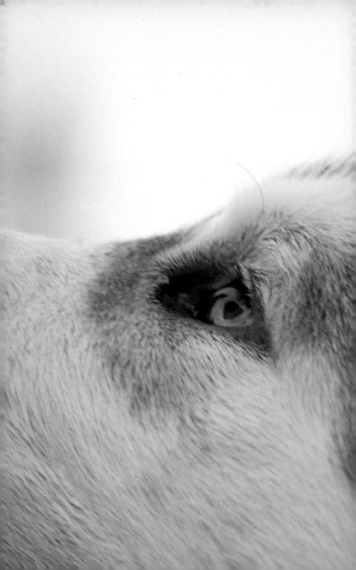

The eyes
are the
windows of
the soul

Keep your friends close

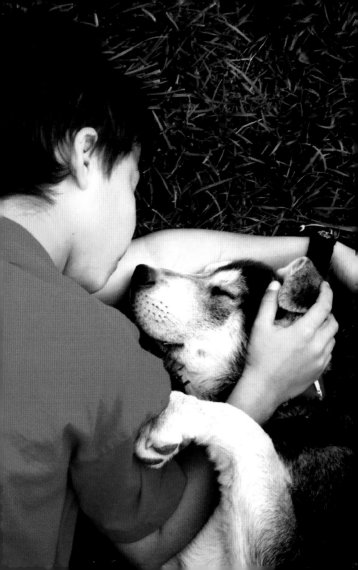

Tomorrow is another day

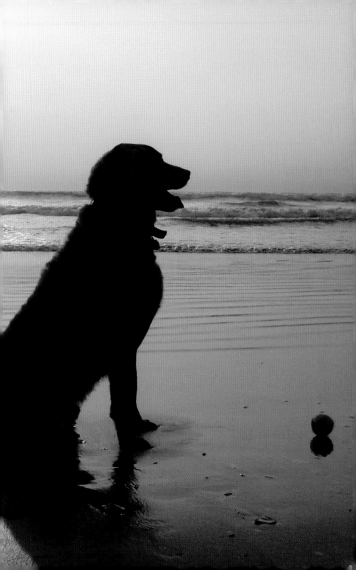

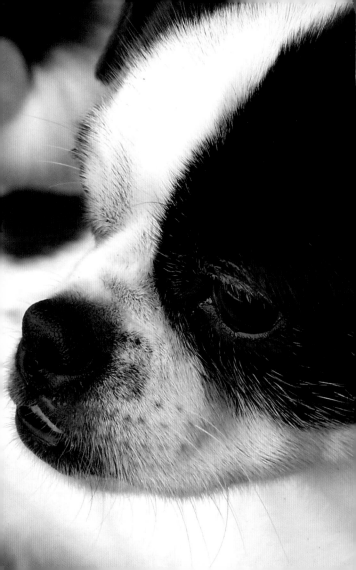

Not everything in life is black and white

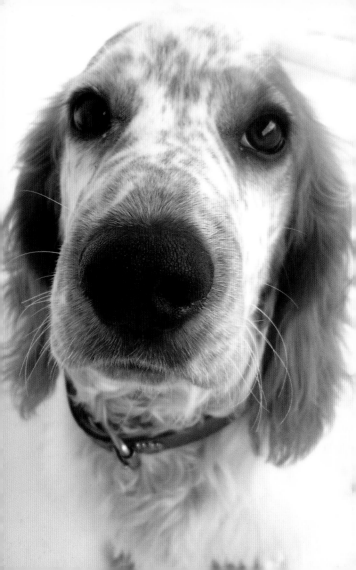

Always follow your nose

Iron bars do not a prison make

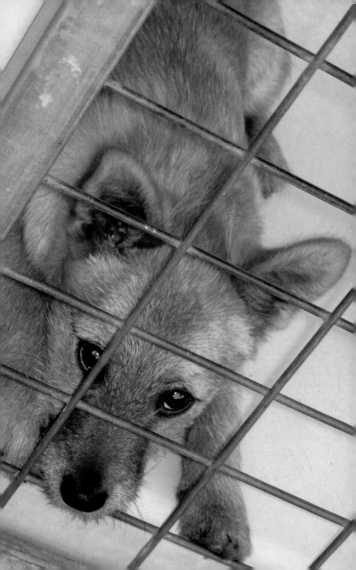

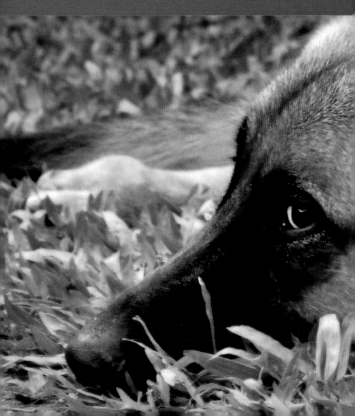

Sorry is
often the

hardest word

Nobody likes a backseat driver

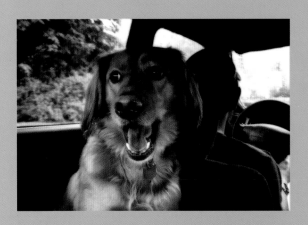

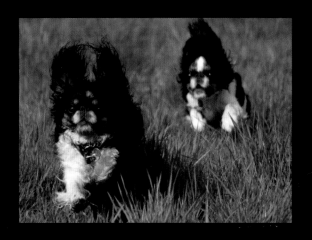

Fools rush in where angels fear to tread

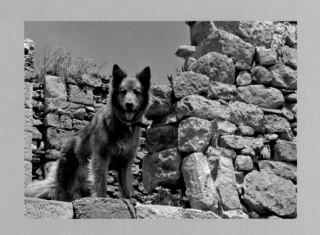

Walls have ears

Possession is nine-tenths of the law

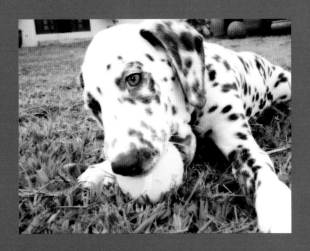

ALL PETS MUST BE ON A LEASH

PLEASE CLEAN UP AFTER YOUR PET

PET WASTE TRANSMITS DISEASE

Rules are made to be broken

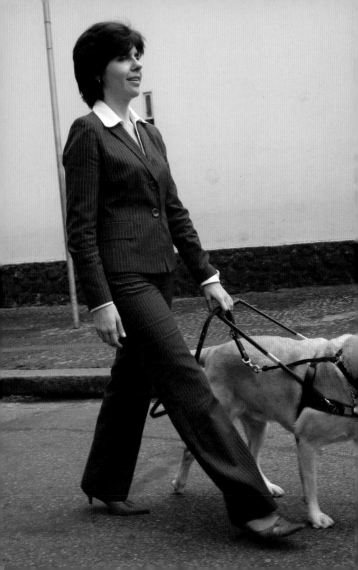

A friend in need is a friend indeed

Keep your ear to the ground

Always look on the bright side

A good
meal stays
with you

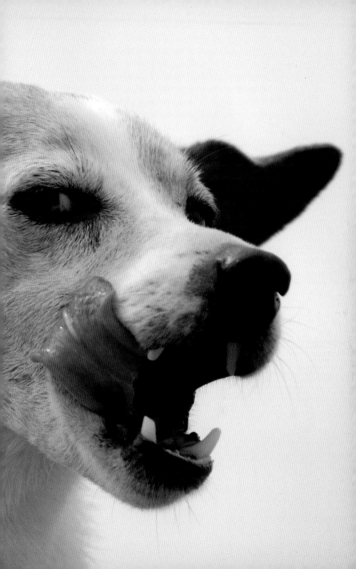

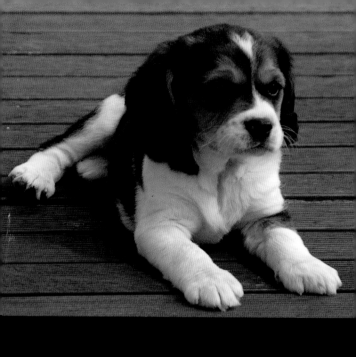

You're only
young once

Good things come in small packages

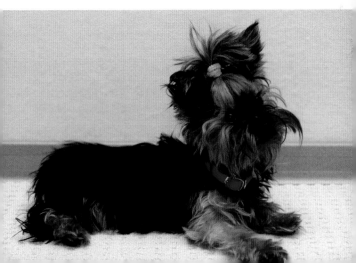

Chains cannot bind me

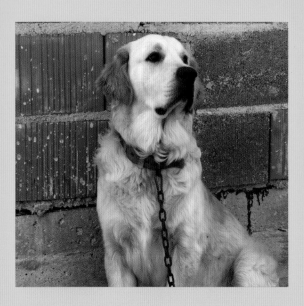

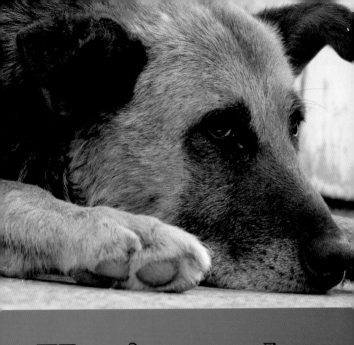

You're only
as old as
you feel

The family that plays together,

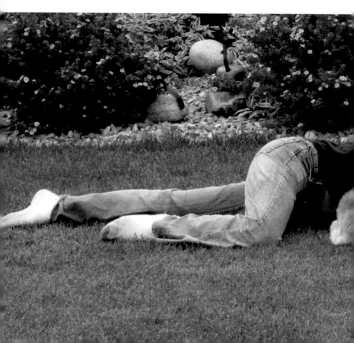

stays
together

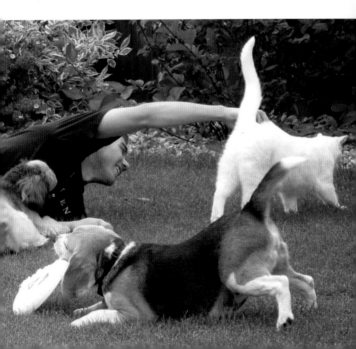

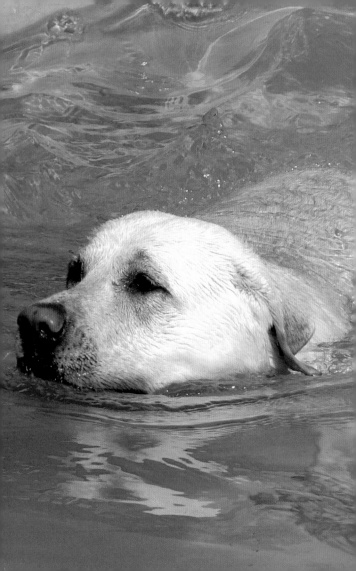

Always
keep your
head above
water

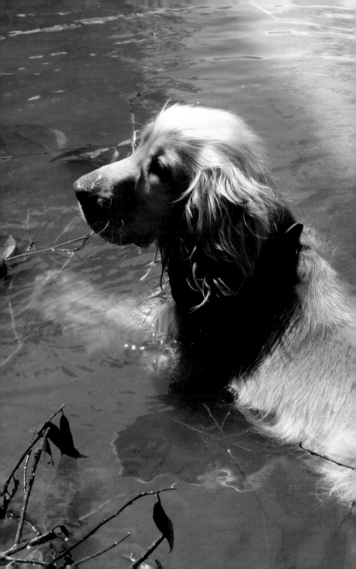

Cleanliness
is next to
dogliness

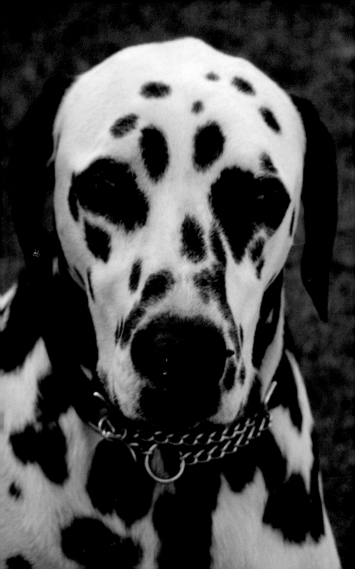

A dalmatian never changes its spots

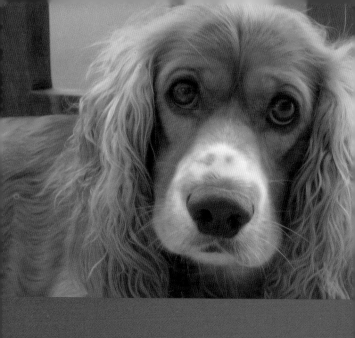

Don't worry
Be happy

A rolling stone gathers no moss

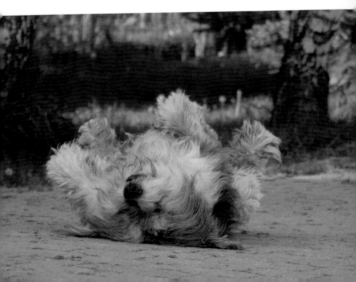

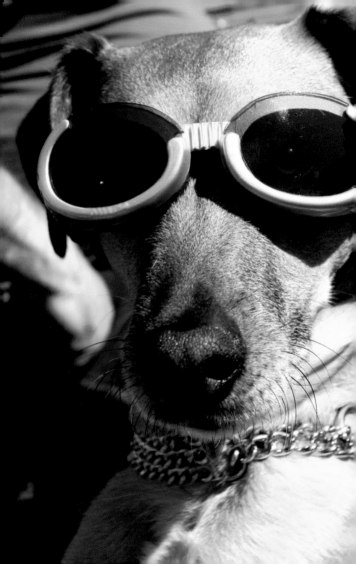

There's always someone cooler than you

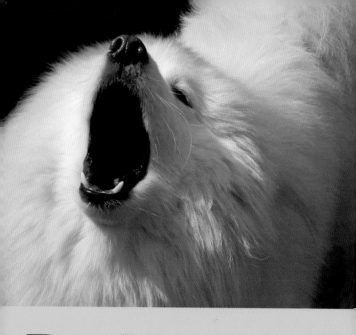

Barking dogs seldom bite

Hold on
to what
you've got

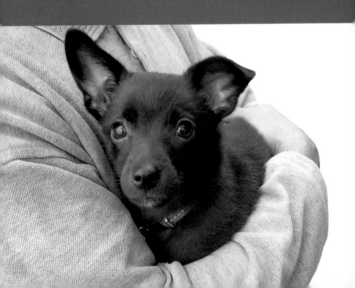

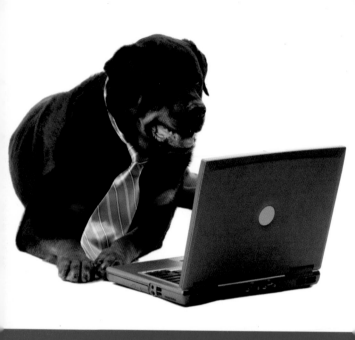

Get yourself
connected

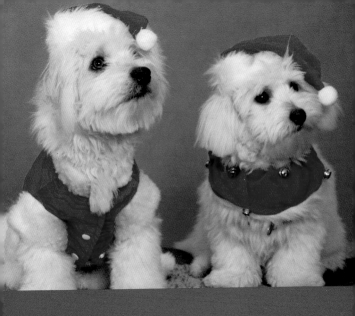

Dress
for the
occasion

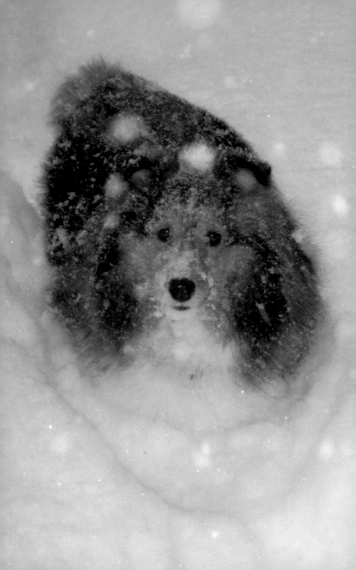

Now is
the winter
of our
discontent

Tongues will wag

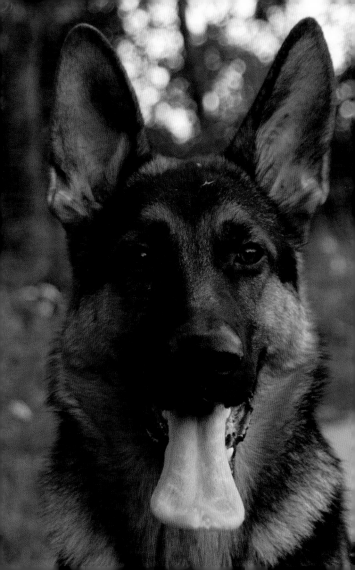

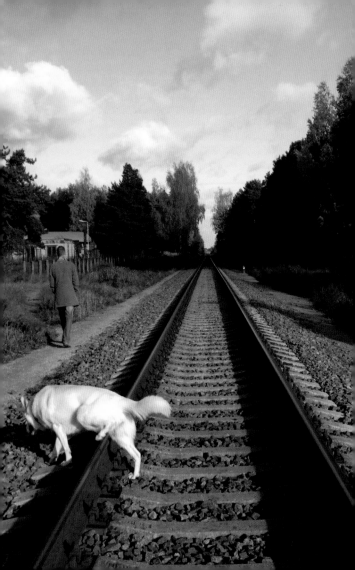

Keep your life firmly on track

Old dog –
new tricks

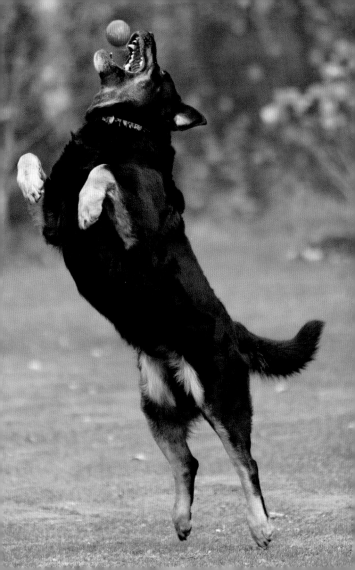

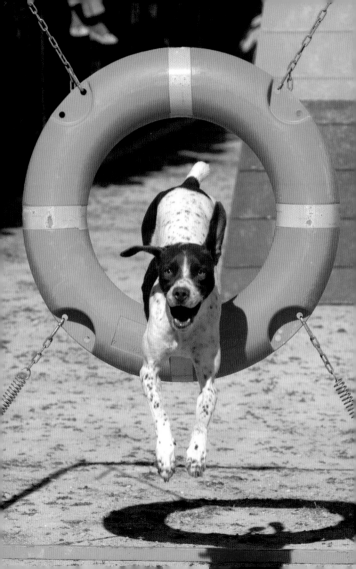

A healthy mind in a healthy body

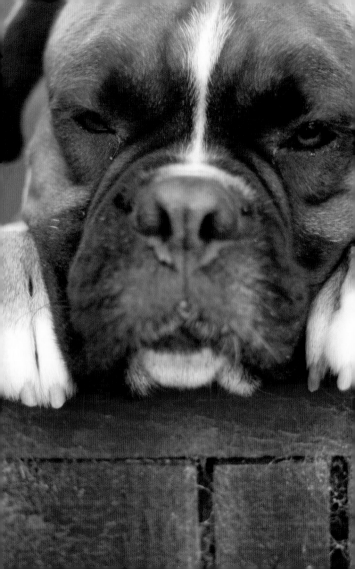

What is
this life if,
full of care,
we have no
time to
stand and
stare?

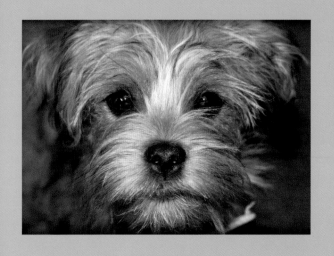

Worrying
never solved
anything

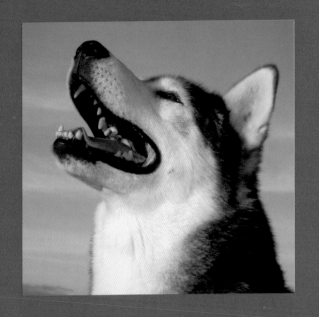

Don't
cry wolf

An hour's sleep before midnight is worth two hours after

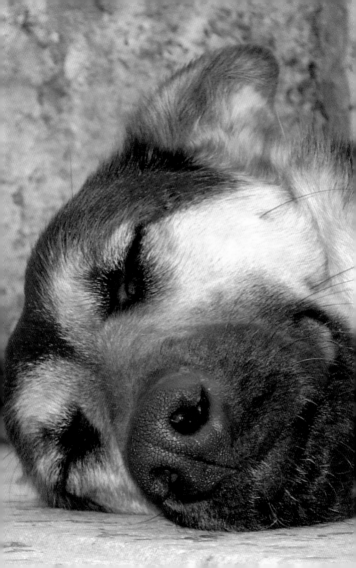

Because it's there

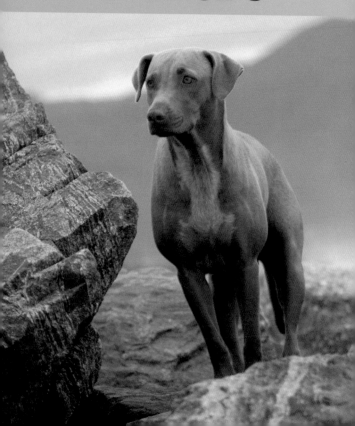

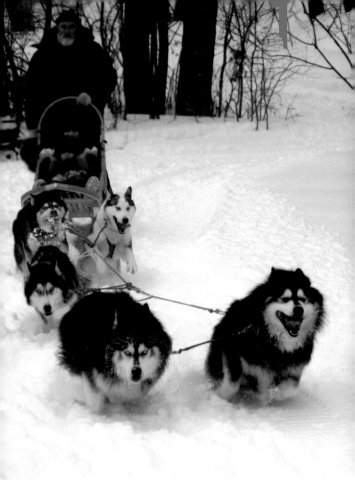

Life's a drag

Work, rest

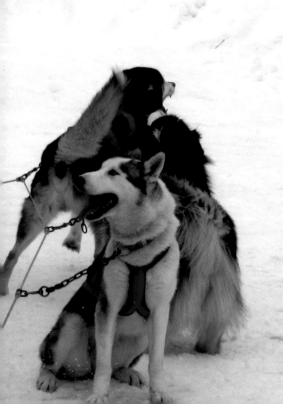

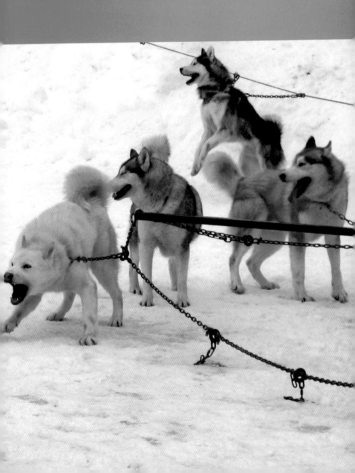

and play

You can't
look into
the future

Why keep a dog and bark yourself?

Keep
young and
beautiful,
if you want
to be loved

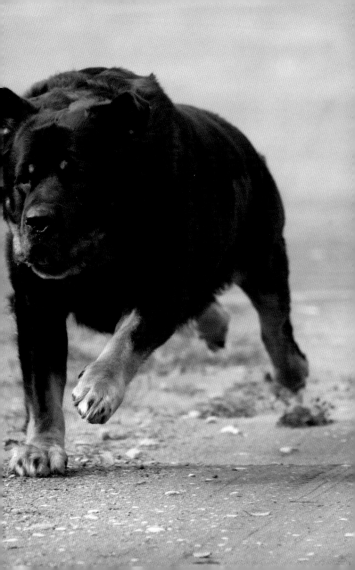

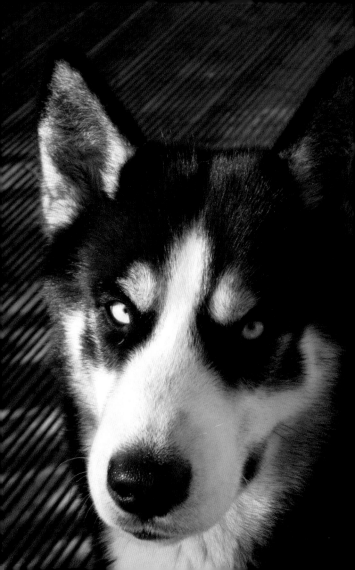

First
impressions
last

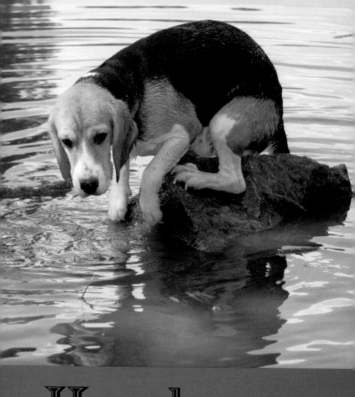

He who
hesitates
is lost

Let sleeping
dogs lie

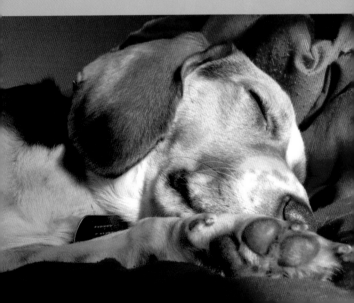

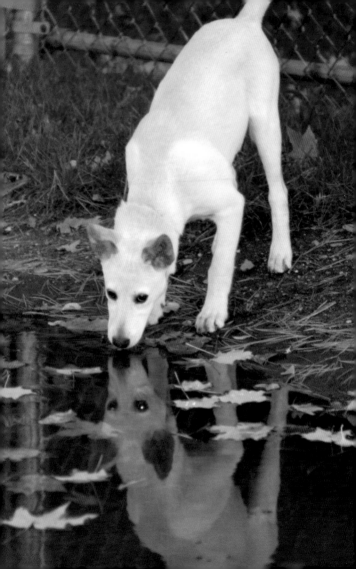

Learn to handle your drink

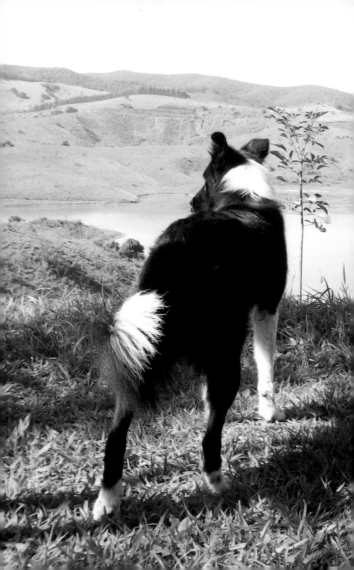

Always take
the high
ground

Look after
number one

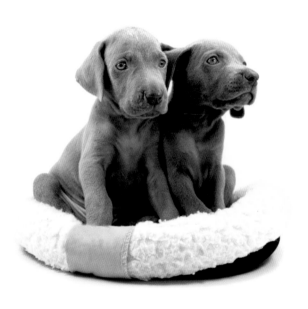

Any port in
a storm

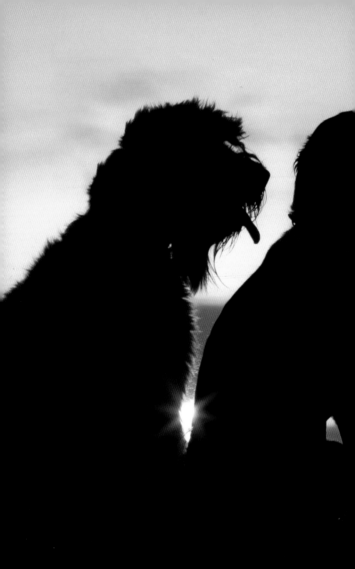

It's always
darkest
before
the dawn

Great oaks
from little
acorns grow

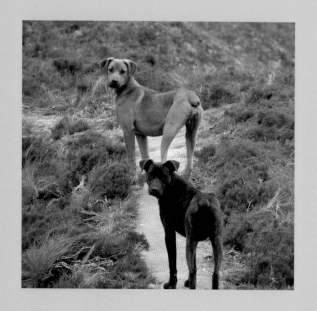

Take the road less travelled

Age has its rewards

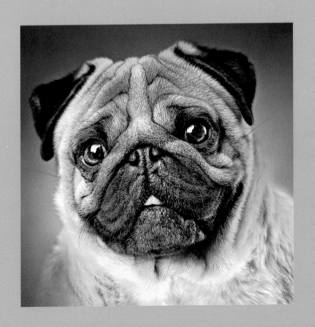

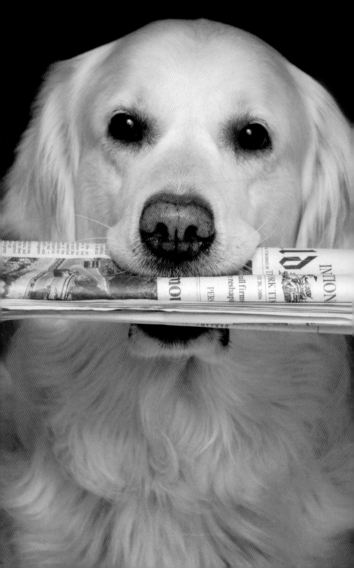

Stay
informed

Dignity is everything

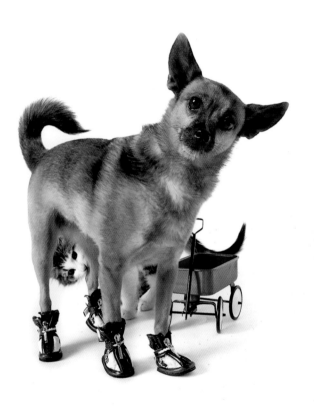

You scratch
my back and

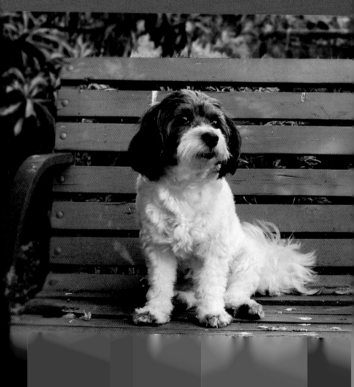

I'll scratch

yours

Every dog
has its day

There is
safety in
numbers

Don't let the
sun go down
on your anger

Stand up and be counted

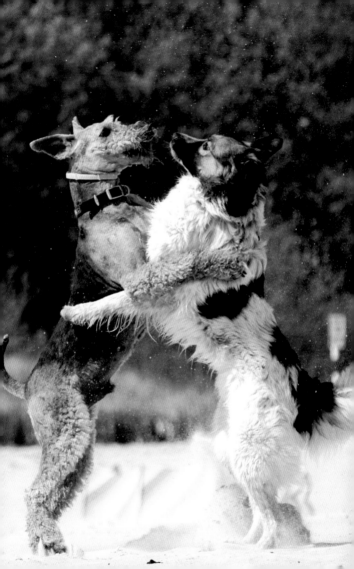

You can
run but you
can't hide

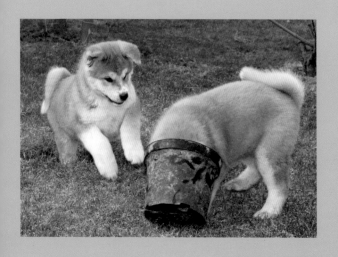

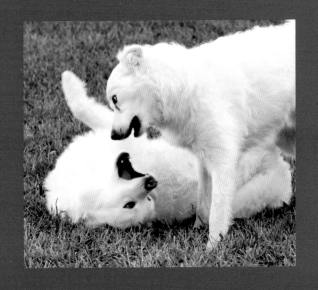

Jaw-jaw is
better than
war-war

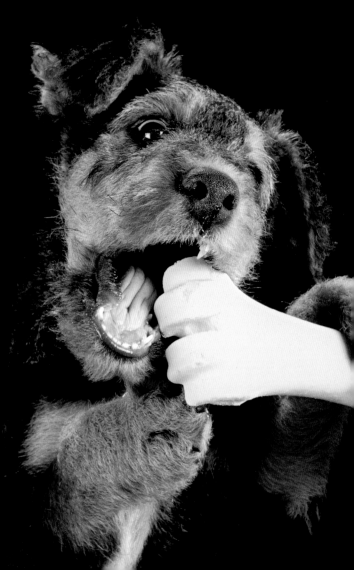

You can't have too much of a good thing

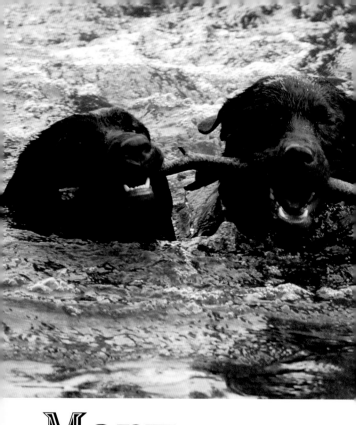

Many
hands

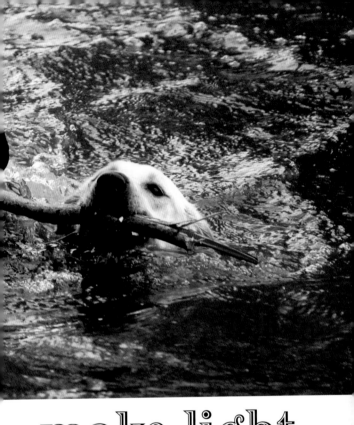

make light
work

Teach your children well

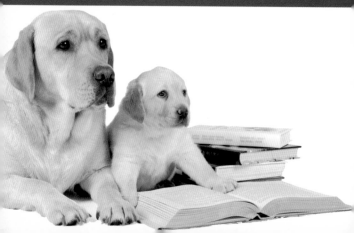

Knowledge
is power

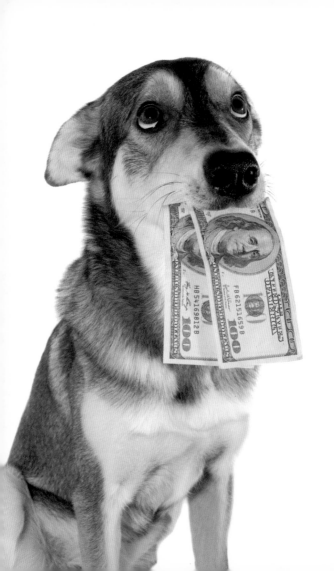

Money
makes the
world go
round

Smiling is infectious

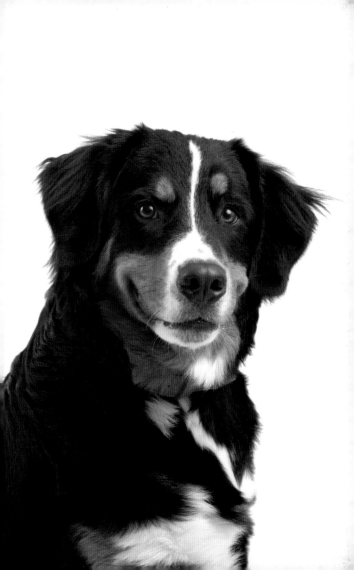

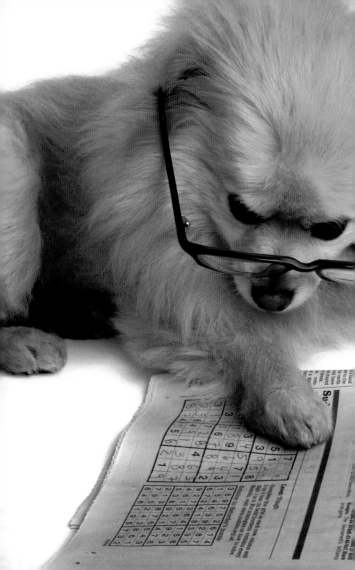

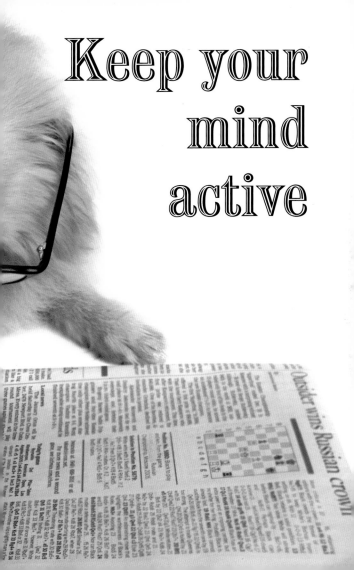

Keep your
mind
active

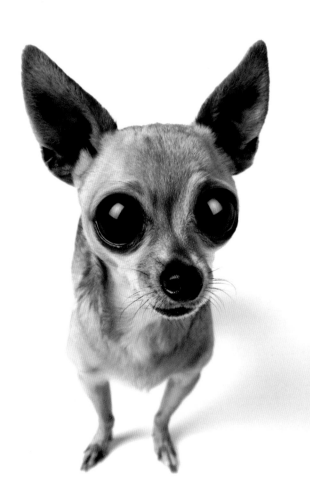

Go in
with both
eyes open

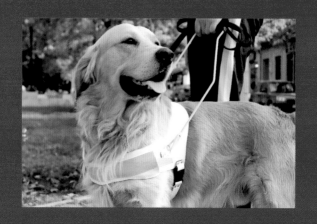

Live a
good and
useful life

You can't take it with you

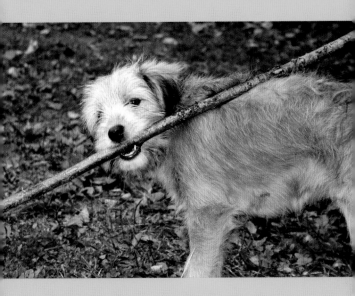

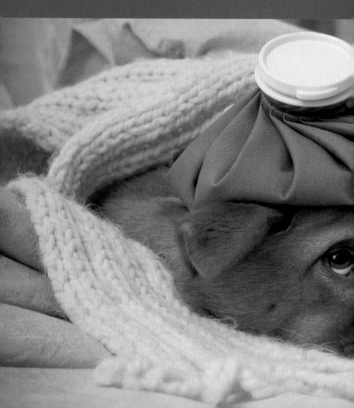

Coughs and sneezes

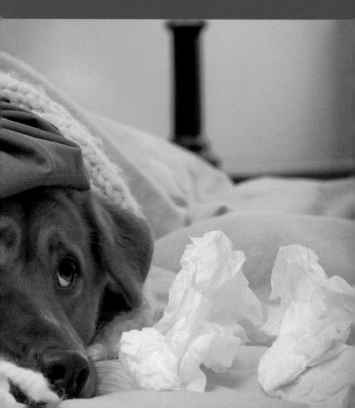

spread
diseases

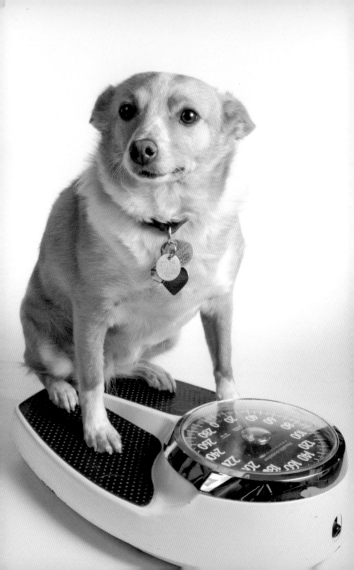

Eat
yourself
fitter

Don't look a
gift horse

in the
mouth

Don't be
a big head